# MARCEL DUCHAMP

## THE AFTERNOON
## INTERVIEWS

### CALVIN TOMKINS

*Marcel Duchamp: The Afternoon Interviews*
by Calvin Tomkins

First edition of 5,000

Published by:
Badlands Unlimited
P.O. Box 320310
Brooklyn, NY 11232
Tel: +1 646 450-6713
operator@badlandsunlimited.com
www.badlandsunlimited.com

Enhanced e-book with multimedia content available on Apple iBooks, Amazon Kindle, and other e-readers. For more information, visit www.badlandsunlimited.com

Editor and designer: Paul Chan
E-book design: Ian Cheng
Copy editor: Sam Frank
Consulting editor: Karen Marta
Production: Madeline Davis, Micaela Durand

Special thanks to Susan Anderson, George Baker, Ruby Chan, Paul Elitzik, Michelle Elligott, Dodie Kazanjian, Mathieu Malouf, Molly Nesbit, John Oakes, Marlo Poras and Matthew So.

Text transcribed and edited from original audio recordings with permission from the MoMA Archives, Calvin Tomkins Papers, V.2 and V.3. The Museum of Modern Art Archives, New York.

Images reprinted with permission from the Alexina and Marcel Duchamp Papers; Philadelphia Museum of Art, Archives.

Front cover design by Paul Chan
Additional cover design work by Ian Cheng and Brendan Dugan
Front cover photo: Marcel Duchamp seated by Gianfranco Baruchello, Cadaques, Spain, 1963.
Courtesy of the Alexina and Marcel Duchamp Papers; Philadelphia Museum of Art, Archives.

Paper book distributed in the Americas by:
ARTBOOK | D.A.P.
155 6th Avenue, 2nd Floor
New York, NY 10013
Tel. +1 800 338-BOOK; fax: +1 212 627-9484
www.artbook.com

Paper book distributed in Europe by:
Buchhandlung Walther König
Ehrenstrasse 4
50672 Köln
order@buchhandlung-walther-koenig.de

Printed in the United States of America

ISBN: 978-1-936440-39-9
E-Book ISBN: 978-1-936440-40-5

www.badlandsunlimited.com

*To whom it may concern*

# CONTENTS

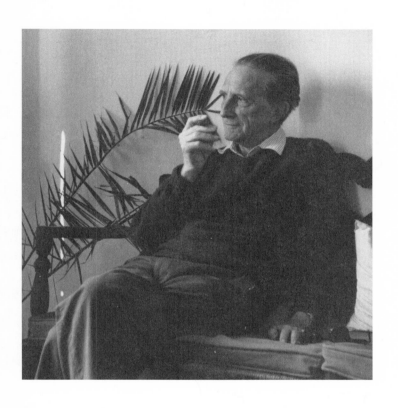

# INTRODUCTION
New York, 2012

Paul Chan: When did you first meet Duchamp?

Calvin Tomkins: That would have been in 1959. I was working for *Newsweek* magazine at that time. *Newsweek* in those days had no art coverage. But occasionally—two or three times a year, maybe— there'd be a story on art some editor thought we should cover and so they'd pull a writer from another section. I was writing for the foreign-news section at the time.

PC: *Newsweek* put you on the Duchamp beat.

CT: Right. I got the call one day to go and interview Marcel Duchamp, which was a complete surprise to me because I knew nothing whatsoever about art. And I guess I probably thought that he was long in the past. I'd heard of him, of course. The first monograph on him and his work ever published came out in '59 in Paris and in New York, and the editor gave me a copy of the book. I only had a couple of hours to skim through it.

The interview was already arranged. It was at the King Cole Bar in the St. Regis hotel, a New York landmark. On the wall behind the bar there was a huge mural by…oh no, who was the artist? An American popular artist…

PC: Parrish?

CT: Maxfield Parrish. A huge mural by Parrish that showed Old King Cole and his merry court drinking and holding up mugs and dancing around. It was an endlessly kitschy piece of work. I remember quite vividly entering the place and locating Duchamp. We sat down at a table, and he motioned toward the mural and said, "I like that, don't you?" I assumed he was kidding, so I laughed. But then I started to realize that he *did* like it. That was the initial surprise: he thought it was wonderful. I don't think I had a tape recorder in those days. But anyway we started talking, and I was taking notes.

PC: What was your first impression of him?

CT: The thing that really surprised and delighted me was that even though all my questions were very dumb and ignorant, he somehow managed to turn every one of them into something interesting. He had the most enchanting and easy manner. He was at home in his own skin, and he made me—and everybody around him—relaxed.

I remember asking him, "Since you've stopped making art, how do you spend your time?" And he said, "Oh, I'm a breather, I'm a *respirateur*, isn't that enough?" He asked, "Why do people have to work? Why do people *think* they have to work?" He talked about how important it was to really breathe, to live life at a different tempo and a different scale from the way most of us live. Of course later on I learned that he hadn't stopped working at all, that he'd been at work for the last twenty years on a secret, room-size environment that is now in the Philadelphia Museum of Art. But nobody knew about that at the time, except his wife, Teeny.

PC: Is it really true that before Duchamp you knew nothing about art?

CT: Well, I had an interest in it. I started spending lunch hours at MoMA and seeing shows. I didn't really know anything. I'd taken one art course at college, which was on Italian Renaissance painting, and I'd found that quite fascinating. My father was a businessman who had a lot of other interests. In the 1930s he formed a friendship with an Italian artist named Peppino Mangravite, who lived near us where we spent our summers, in the Adirondacks, and as a result of that he began buying not only Mangravite's work but the work of several other artists who were in the same gallery. He never became a

serious collector, but he did buy some things. He bought a Burchfield. In Europe he bought a small Marquet painting and a Dufy watercolor. So there was some art in the house when I was growing up, but it was never a major thing. And I certainly had no real knowledge about art. Meeting Duchamp was crucial to me because I was so fascinated with him that I wanted immediately to know more about him, and that was how I got interested in contemporary art.

PC: How long was that first meeting?

CT: I would say about an hour and a half.

PC: And after that you wrote the piece for *Newsweek*?

CT: It appeared the following week. A colleague of mine said, "That was a very strange interview. I never read an interview in which the guy didn't really answer any question." [*chuckles*]

PC: Did Duchamp ever tell you what he thought of the piece?

CT: No. In fact, later on, when I did a profile on him in the *New Yorker*, he said, "Oh, it was great, very amusing." But Teeny told me he never read it, which is quite possible. [*laughs*]

PC: After that first meeting, when was the next time you saw him?

CT: It was probably a couple of years later, because very quickly after that interview I left *Newsweek* and joined the *New Yorker*. The first long piece I did for them was a profile of Jean Tinguely in 1962. He was the Swiss motion artist who had done a fantastic work in the garden of the Museum of Modern Art called *Hommage á New-York*. It was a huge machine whose sole purpose was to destroy itself, which it did very successfully. And in talking with Tinguely, I kept hearing about Duchamp. Duchamp was the first person Tinguely had seen when he came to this country to do his *Hommage*. And Duchamp had been quite helpful because he knew everybody at the Museum of Modern Art. He was an old friend of Alfred Barr's, and I think he was one of the keys in making that thing happen. I also interviewed Bob Rauschenberg about Tinguely, because Tinguely had asked him to contribute something to the machine in the garden. Bob's contribution was a mechanical money thrower.

PC: What was that?

CT: It was a spring under great tension, which had silver dollars stuck in between the coils, and at a certain moment when the machine was destroying itself, a little explosive charge went off and the spring opened and the silver dollars went cascading all over.

PC: We need one of those now.

CT: We do. In any case, Duchamp was a great fan of Rauschenberg, and Rauschenberg had recently become a great admirer of Duchamp.

PC: Were Rauschenberg and Duchamp friends?

CT: They had met in the early sixties. I'm not sure how it happened, but Bob and Jasper Johns went down together to the Philadelphia Museum, where most of the major Duchamps were, and spent a day looking at everything, and this was a tremendously important thing for both of them. Duchamp had not really influenced Rauschenberg or Johns. They had already developed their own individual approaches to art, independently. But learning about Duchamp was very encouraging to them because it seemed like a ratification of the things that they were doing. You see, they were coming out of Abstract Expressionism and they found a lot of affinity between what they were doing and what Duchamp had done.

PC: What were your thoughts about Johns's and Rauschenberg's work at the time?

CT: I became a fan, particularly and first of all of Rauschenberg. I did a profile of him in the *New Yorker* in 1965, so I spent a lot of time with him. That's where I really developed a sense of what

was going on in contemporary art—that kind of thinking, that kind of freedom, that kind of exploratory, experimental attitude. Johns's work seemed more mysterious and hermetic to me. I wasn't able to write about him until much later.

PC: How did your book *The Bride and the Bachelors* come about?

CT: When I starting writing that series of profiles in the *New Yorker*—which I didn't realize was a series until later—I did Tinguely, and then Rauschenberg, then John Cage, then Duchamp. Somewhere along the way I realized that Duchamp was the key figure for the other three. They were all children of Duchamp.

PC: Did Duchamp acknowledge that fatherhood?

CT: Not really. He liked them, and he liked their work, but he always dismissed the question of influence. He said, "People like to say that, but I don't feel as though I'm an influence on anyone."

PC: What was your experience with Duchamp when you wrote the profile of him in the *New Yorker?*

CT: My recollection is there was very much the same kind of ease in all my dealings with him. As I said, anything you asked him, it would become a

very interesting question for him. He was never dismissive or impatient. And he had this tremendously youthful spirit. I don't recall exactly when, but he said once, "You must remember, I am ten years older than most of the young people." That's exactly how I thought of him: someone who was always curious and perpetually young.

PC: You've interviewed and profiled many artists in the *New Yorker*. I wonder if the sensibility you feel Duchamp possessed is a rare thing among artists?

CT: Oh, yes. I've never really found that kind of ease with anybody else. There was an instant rapport with Rauschenberg, so it was very easy to talk with him. But I never found anyone who was less burdened by ego than Duchamp.

PC: Where do you think that ease came from?

CT: I've often wondered if he was always that way, and I think the answer is that he was not. When I worked on his biography for nine years, I found that in his earlier years he had been quite different. He had withdrawn his *Nude Descending a Staircase* from the 1912 Independents exhibition in Paris because its subject matter offended his fellow Cubists—his two brothers actually came and asked him to change the title—and the experience had left him with a feeling of rejection and

bitterness that lingered for a long time. He was very much a loner, someone who refused to participate in things other artists were doing, and I think this reinforced his need for complete independence. He did have enormous success with *Nude Descending* when it appeared at the Armory Show in New York in 1913. It was for a while the most famous painting in America. But after a year or so of mini-celebrity in New York, he went off in an entirely different direction, and I think he felt that there wasn't any particular future for him in the art world. There was a long period—maybe thirty years—in which he functioned on the fringes of that world but wasn't part of it, and deliberately so. He didn't *want* to be part of it. He didn't want to be associated with the Dadaists, even though they were close to his thinking in many ways. The Surrealists, particularly André Breton, idolized him, but he always kept his distance from them. For a long time he felt isolated—he isolated himself, and he had a great contempt for the whole monetization of art. He was unwilling to play the game.

PC: Do you think the solitude led him toward becoming more himself?

CT: Well, several things happened to him when he came back to live in New York for good, during the Second World War. He fell deeply in love with a married woman named Maria Martins.

She was the wife of the Brazilian ambassador to Washington, but she was also an artist, a sculptor who studied with Lipchitz in New York. She knew a lot of the artists, and she had affairs with Lipchitz and I think Mondrian and a few others.

PC: Busy.

CT: Very. She and Duchamp met and fell in love. She had always managed not to fall in love with the men she captivated, but this time she really did fall in love, and so did he. It was a new experience for him, too. But it did not end happily, because after a few years her husband was transferred to Paris, and she elected to follow. Duchamp desperately wanted her to stay and live with him. But she didn't want to leave her husband or her children, and so the affair ended. Then quite soon after that, in 1951, he met Teeny Matisse, the wife of Pierre Matisse. They had just been divorced, and Duchamp and Teeny fell in love and they eventually married. And his life really changed. It became much more comfortable.

PC: After Teeny?

CT: After Teeny. See, Marcel never had money. One of the things he'd done was live on practically nothing. Teeny didn't have a lot of money, but

she had quite a bit of art she could sell. And his life became more comfortable and much happier.

PC: What was Teeny like?

CT: Totally delightful. She was a lovely woman. She came from Cincinnati, and she had studied art in Paris. People said that when she was married to Pierre Matisse she was sort of in the background, because Pierre always wanted center stage. But when she got loose from him and married Duchamp, her whole personality changed. She became very, very popular with all sorts of people. She was just irresistible. She also had a very young spirit. It was really a wonderful match. And I think largely because of that, Duchamp changed. He became much easier on himself, and not nearly so aloof and isolated.

PC: Did you hang out with both Teeny and Duchamp?

CT: I went to dinner at their place a number of times, and he and Teeny would come for lunch to a place I had with a previous wife out in Snedens Landing. That's where the photograph that shows him with John Cage was taken, after lunch at our house.

PC: And at this point he's not a subject anymore, he's a friend.

CT: Yes.

PC: What would you talk about as friends?

CT: We didn't talk about art. He never really liked to talk about art, but he would talk about things that were going on in the art world, like the Happenings. He actually went to some of the Happenings and thought they were great. He said theater had always bored him, but the Happenings were supposed to be boring and so he found them quite entertaining.

PC: But he was interested in what was going on in the world?

CT: I'm not sure how deeply he went into foreign affairs, but he would talk about what was going on in the news and about books and things. Although he didn't read much either.

PC: That's what he said.

CT: In his youth, when he worked at the Bibliothèque Nationale, I think he read quite a lot. But that was the only time in his life when he did that. Duchamp was one of those people who could pick things out of the air. He could sense ideas that were emerging, and new developments. For example, he was very interested in Warhol.

PC: Why?

CT: He just thought that what Warhol was doing was very original, and he must have felt it had some resonance with the things he had done. He said, "What's interesting is not that somebody would want to paint twenty-seven soup cans. What's interesting is the mind that would conceive of painting twenty-seven soup cans." And I think he was getting at something.

PC: What do you think he was getting at?

CT: The emergence of Conceptual art. From the beginning of our discussions, Duchamp would talk about how he wanted to restore art to the service of the mind. In the Renaissance, art had been what Leonardo called a *cosa mentale*. But gradually it had become what Duchamp described as retinal art: something that appealed to the eye, and to the eye alone. He felt that the Impressionist period was completely retinal, and so were the Abstract Expressionists.

PC: Did your thinking around his work change over time?

CT: Sure, my thinking was changing all the time. In the course of working on Duchamp's profile I read a lot about the Dada movement, and I was even able to interview some ex-Dadaists. I

also had to learn about Surrealism. I was just picking things up as I went along. But from the beginning there was something that really appealed to me about Duchamp's attitude and his sense of humor. The previous period, the Abstract Expressionist period, had been very lacking in humor.

PC: No joke?

CT: No joke. They took themselves very, very seriously. And the rhetoric that surrounded that movement was amazing. "We stand alone in the desert..." That kind of thing. They had this heroic concept of themselves as...

PC: Martyrs?

CT: As martyrs. And at the moment I was getting interested in art, there were Rauschenberg and Johns, and then Pop art, and Minimal art, and color-field painting, and early experiments with video and film. The whole attitude was one of "anything can happen." It was a very exciting period in the sixties because you felt every week there was some new discovery. And it became more and more evident that everything that was going on was connected with Duchamp.

PC: How would he take the company of younger artists who wanted to be around him, like Johns and

Rauschenberg? Would he hang out with them?

CT: I asked both of them this question, and they made it clear they didn't spend a lot of time with him. There was always this feeling that he was a god-like figure, and that you had to respect his time. For years, John Cage, who first met him in the forties in New York, was so in awe of Duchamp that he didn't want to take up his time. But in the sixties, John got over that and asked Marcel to give him chess lessons. Marcel agreed. And then of course it wasn't Marcel who gave the lessons. It was Teeny! Marcel would occasionally look over their shoulders and say, "You're playing very badly." [*laughs*]

PC: When did you decide to write the biography on Duchamp?

CT: The book came out in 1996. But you know there was an earlier biographical work?

PC: The Time-Life book?

CT: That's right. About a year or so after my profile appeared in the *New Yorker*, the editors of Time-Life were doing the Time-Life Library of Art, in many volumes. The first one was on Leonardo da Vinci. The second was on Michelangelo, the third was on Delacroix, and the fourth was on Duchamp, which was mindboggling. Anyway,

because I had done the *New Yorker* profile they asked me if I would do it. I'll never forget that first editorial meeting at the Time-Life offices in Rockefeller Center. There were about twelve people around a table. We were mostly discussing what photographs might be available, and so forth. A question came up at one point, and I didn't know the answer, and I said, "Well, I don't know, but I'm seeing Marcel on Friday so I'll ask him." There was a dead silence. I looked around the table and realized that they all thought he was dead! I think if they had known he was alive, they would never have scheduled the book.

PC: But it was too late at that point?

CT: It was too late! They had already put it into production.

PC: So what did Duchamp think of that book? You think he read it?

CT: I'm not at all sure.

PC: You've thought about Duchamp's life and work for more than fifty years now. I just want to get your impression of what you think Duchamp's legacy is today.

CT: I think one of the most important elements is this attitude of complete freedom: freedom from tra-

dition, freedom from dogmas of any kind. And the way in which he took nothing for granted. He spoke about how he doubted everything and, in doubting everything, found ways to come up with something new. This has certainly been a big part of his legacy: this need, this passion to question everything, even the very nature of art. The real point of the readymades was to deny the possibility of defining art. Art can be anything. It isn't an object or even an image, it's an activity of the spirit. And this idea carries through all of his work. These things he did that nobody had done came about because of a freedom he was able to find for himself. And he avoided the kind of responsibilities that would inhibit that freedom. He lived extremely simply, on very little money. He reduced his wants to the bare minimum, which left him free to explore. This experimental attitude is probably his most influential gift.

PC: Today there are many artists who claim to be Duchampian. There are even those who call themselves "readymade artists." Do you find Duchamp's spirit in their work?

CT: Not really. I think Duchamp himself realized that this attitude he developed for himself opened all sorts of doors, including the door to lazy art. If art can be anything, then maybe you

don't have to work so hard. Some of today's conceptual artists seem to feel that any idea will do for art, even mediocre ones.

PC: You don't find that compelling?

CT: Not always, no. But another aspect of his influence is his humor. Humor had always been pretty rare in art, and I think it's less rare since Duchamp.

PC: Is humor really rare in art?

CT: I'm afraid so.

PC: Reading the interviews you did with him, I was struck by how lively he was, and how he changed over time.

CT: There was a lightness of heart about him that was really...it was one of the things that made you delight in being with him.

PC: Do you think the delight came in part from living light, so to speak?

CT: Probably. He wasn't offering answers or solutions. He was trying to understand through his work, and sometimes through not working, how to live life in a way that was going to be satisfy-

ing. You know, I've had this feeling. I just read a new book on Montaigne...

PC: *How to Live* by Sarah Bakewell?

CT: That's it! It's a really good book. And I think that Duchamp is kind of a Montaigne-like figure.

PC: What do you mean?

CT: He wasn't telling you how to live so much as he was just trying to find out for himself. His friend Henri-Pierre Roché once said Duchamp's greatest work was his use of time.

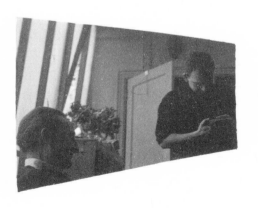

# THE AFTERNOON INTERVIEWS

New York, 1964

Calvin Tomkins: Today I'd like to ask you about your life in New York before the First World War. You've said that the city has changed a great deal since then.

Marcel Duchamp: Well, life has changed all over the world. One little detail is taxes. In 1916 and 1920 taxes were nonexistent, or so unimportant that people never thought of them. Today, when March or April approaches, everybody is hectic about paying taxes and saying they can't buy this or that because their taxes are due. This form of fever did not exist at all back then. And the rest of life as a whole was much quieter, at least in the relationship of man to man. There was less of the rat race that we see now. I mean, the whole globe is rat racing now. America is no exception.

CT: And yet in spite of all the commercialism and the rat race it's still a fact that there's such a great deal going on among younger artists now.

There's so much more inventiveness and excitement...

MD: Yes, there was less activity then than now. There were not as many artists as today. The profession of being an artist, of becoming an artist, was only left to a few, compared to what it is today, when a young man not having special aptitude for anything will say, "Well, I'll try art." In my day, young people who didn't know what to do tried medicine or studied to become a lawyer. It was the thing to do. It was rather simple, and the examinations were not as long as they are today. You could become a doctor in four years, in France, at least. And here, I don't know, it was probably also this long, not like now. All these things make a large difference in the lives of young people today.

CT: Do you think the idea has spread that art is easy?

MD: It's not that it's done more easily. But there is more of an outlet for it. Exchanging art for dollars did not exist then except for a few artists of that time. The life of an artist in 1915 was nonexistent as a money-making proposition—far from it. Many more people are miserable today because they try to make a living from painting and can't. There is so much competition.

CT: But isn't all the new art activity in one sense a healthy sign?

MD: In a way, if you consider it from the social angle. But from the aesthetic angle I think it's very detrimental. In my opinion such an abundant production can only result in mediocrity. There is no time to make very fine work. The pace of production is such that it becomes another kind of race, not rat but I don't know what. [*laughs*]

CT: Doesn't this also reflect a change in the concept of what art is—a loss of faith in the creation of masterpieces, and an attempt to make art a part of daily life?

MD: Exactly, it's what I call the integration of the artist into society, which means he's on a par with the lawyer, with the doctor. Fifty years ago we were pariahs—a young girl's parents would never let her marry an artist.

CT: But you've said you liked being a pariah.

MD: Oh, yes, of course, it may not be very comfortable but at least you have a feeling that you may be accomplishing something different from the usual, and maybe something that will last for centuries after you die.

CT: Then you disapprove of the integration of the artist in society?

MD: It's very pleasant in a way, because there is the

possibility to make a living. But that state is very detrimental to the quality of the work done. I feel that things of great importance have to be slowly produced. I don't believe in speed in artistic production, and that goes with integration. I don't believe in the rapidity, the speed, that is now introduced in art production so you can do it quickly. The quicker, the better, so they say.

CT: You said that your own work has contributed to the situation that we have now.

MD: Yes.

CT: The creation of the readymades, for example...

MD: But you see, when I did produce things like that, it was not with the idea of producing thousands of them. It was really to get out of the exchange-ability, I mean the monetization, one might say, of the work of art. I never intended to sell my readymades. So it was really a gesture to show that one could do something without having, in the back of your head, the idea of making money through it.

CT: You didn't sell any of readymades?

MD: Never. Never did I sell them. Not only that, never did I show them. Nobody saw them until twenty years ago. When I showed them at Bour-

geois in 1916—it was as a great favor that Bour-
geois agreed to put them in the exhibition, with
a tongue in his cheek (not mine, his). So if I am
responsible for some of the gestures today, I am
only responsible to a degree, not altogether.

CT: What do you think of the contemporary no-
tion that art is not something fixed, but as
Harold Rosenberg said, "a center of psychic
energy"? Instead of the fixed masterpiece hang-
ing on the wall, it should be something else.

MD: It could be. Of course, the difficulty is to make the
people who buy understand that, because there's
a great deal of traditionalism in collectors. They
are not generally intelligent enough. Collectors
tend to feel things. They are feelers, not intel-
lectuals. So to make them understand that what
they buy will not be made for the wall or for the
decoration of their home is already a big step for
them to take. So ready are they to say, "Well, I'll
buy that to show my friends mainly," or "When
they come to my cocktail party, I want to show
them the Rauschenberg," and so on. They want to
look at the colors and the combination of forms,
and casually say, "Oh, I love that. Don't you like
it? Oh, it's marvelous." This is the vocabulary.
It's a marvelous vocabulary, isn't it? [*chuckles*]

CT: Would it be healthier if the collector accepts

these works more in the spirit of how they were created?

MD: There would be at least a chance of going back to a spiritual approach, which is completely lacking today. Or it's not lacking completely but is more or less obviated by the money value of the paintings. The painting may be very spiritual or so, but the collector always ends up saying, "And I paid so much for it." Either too little or too much—which is good in both instances. If the amount is too little, he asks, "Is this wrong?" And if it's too much he says, "I'm proud because I've paid so much for it."

CT: Do you feel that the commercialization of art in our time is the leading influence on art now?

MD: Yes, it has been. It is the effect of the integration. Integration really means that whatever a doctor or a lawyer does is paid for, and it is understood that he should be paid for what services he renders. In the case of the artist—integrated for the first time in a hundred years—he has to be paid for what he does. It's normal. It's one of the characteristics of the integration. It's automatic. It's not even thought out or explained anywhere.

CT: How do you think a young artist could attempt to break out of the present situation, as you broke out of the situation before the First World War?

MD: There was a symposium in Philadelphia three years ago on the subject, more or less, of where we go from here. And I ended by saying that I think the great man of tomorrow in the way of art cannot be seen, should not be seen, and should go underground. He may be recognized after his death if he has any luck, but he may not be recognized at all. Going underground means not having to deal in money terms with society. He wouldn't accept the integration. The underground business is very interesting because an artist may be a real genius today, but if he is spoiled or contaminated by the sea of money around him, his genius will completely melt and become zero. There may be ten thousand geniuses today but they will never become geniuses, unless they have luck and very great determination.

CT: Well, in a sense you have gone underground, haven't you?

MD: No. Maybe I was underground at the beginning but now I'm not underground, people ask me so many questions! [*laughs*] It's probably my doom, too.

CT: Parenthetically speaking, it seems a little strange to see you living here surrounded by paintings by Matisse, who was certainly a retinal artist.

MD: Well, they belong to my wife, and I accept them. [*laughs*] And also, you know, the surroundings in which you live in my case don't interest or bother me at all. I could live with the worst calendar picture, and with any sort of furniture, because I never put taste in my life. Taste is an experience that I try not to let come into my life. Bad, good, or indifferent, it doesn't come in. I'm so against interior decorators.

CT: Are you against taste of any kind, including bad taste?

MD: No!

CT: For instance, Léger said that at times, he liked bad taste. That he really responded to it...

MD: Bad, good, or indifferent, I don't care. You don't have to be happy or unhappy about it, you see? That's the trouble: taste can't help you understand what art can be. The difficulty is to make a painting that is alive, so that when it dies in fifty years, it goes back into that purgatory of art history. As far as art history is concerned, we know that in spite of what the artist said or did, something stayed on that was completely independent of what the artist desired; it was grabbed by society, which made it its own. The artist doesn't count. *He does not count.* Society takes what it wants.

CT: But the artist shouldn't concern himself with this.

MD: Absolutely not, because he doesn't know. He thinks he knows. He's painting a nude, and he thinks he knows what he's doing. His painting is nice looking. But it has nothing to do with what the onlooker sees in it: he sees an entirely different side. The priority of the connoisseur or whatever you call him isn't to speak the same language as the artist. But then fifty years later, there is a new generation that comes and says, "What did they say? What did they speak?"

CT: That's what you referred to in your Houston talk.

MD: Yes, the interaction of the onlooker, which makes the painting. Without that, the painting would disappear in an attic. There would be no actual existence of a work of art. It's always based on the two poles, the onlooker and the maker, and the spark that comes from that bipolar action gives birth to something—like electricity. Don't say that the artist is a great thinker because he produces it. The artist produces nothing until the onlooker has said, "You have produced something marvelous." The onlooker has the last word on it.

CT: In other words, the artist should not consider himself a supreme being.

MD: You try that! An artist, if I try to discuss that, will say, "You're crazy! I know what I'm doing." They're such supreme egos. It's disgusting. I've never seen anything worse than an artist as a mind. It is very low, uninteresting as far as the relationship of men is concerned.

CT: Does this apply to artists today or to all artists?

MD: All artists. Nietzsche or de Kooning, it's all the same thing.

CT: What about artists in the Middle Ages?

MD: They had the worst form of it, which was religion. They were serving God.

CT: But isn't this attitude changing now? The Pops seem to take themselves so much less seriously than the Abstract Expressionists.

MD: Yes, there's a kind of humor there, which is not bad. It might even be the announcement of a period when humor would be introduced—when people would not be so serious and money would not be so important and there would be time for leisure. You have to find a system in which you give enough money to everybody without their having to work for it, because the work is done.

CT: Have you ever tried to argue these ideas with another artist?

MD: No. I hate to argue in general. You don't argue with artists, you just say words, and they say words, and there is absolutely no connection. Absolutely none. Beautiful on both sides, full of new words and flourishing language and so forth, but no actual exchange and no understanding of the other one's ideas.

CT: What about the importance of the café life in Paris, when artists got together and exchanged ideas?

MD: In the case of the Impressionists it could be a very useful thing—one artist would say a word that caught the imagination of the others, that's true. But it's a very, very artificial thing.

CT: Coming back to the commercialization idea, how important is the role of art dealers in the life and work of artists?

MD: Very good and very bad at the same time. They have launched so many young people. They are the lice on the back of the artist. The collectors are also parasites. The artist is the beautiful flower on which all these parasites go around. I like them very much because they are very nice people, but that has nothing to do with their essential quality, which is to be a parasite on the artist.

CT: A dealer like Vollard has played a great role, though.

MD: Yes, a man like Vollard is a form of advanced posterity. He could accept Cezanne and put him on a pedestal, and posterity had to accept it. He had something in himself which is comparable to what an artist may give, spiritually speaking. There are good dealers and bad dealers, like everything else. It's a very curious form of parasitism; instead of being a bother, it's an enhancer.

CT: Did you ever engage in that kind of commercial activity?

MD: Yes, a little bit. I bought some Picabias in 1926, because my father died and I had some money, a little money, even though my poor father had spent so much of it before. I bought a few Picabias that I put into a sale, an auction, at the Hôtel Drouot. It was mainly the period of the transparencies and the Ripolins of 1920 to 1921. It was not a great success, but it was an amusing joke. I made a little money, and divided it with Picabia, who didn't really need it.

CT: Any other transactions?

MD: I would buy some paintings for the fun of it, for very little money. I never did it very seriously. There was very little money to make. Of course we lived on less money then. But I didn't make a point of living like that at all. It just happened that, knowing all these people like Arp and so

on, I would be tempted to buy things from them for no other reason than that they needed some money, and then later on I would make a comparatively great profit on what I had bought. The group around Breton did it more seriously because they had no other way; their books didn't sell enough.

CT: Were your feelings about the commercialization of art as strong then as they are now?

MD: It was the beginning of the race for pennies. You could feel it—the beginning of monetizing art in the social form. You could feel that a young doctor, a young lawyer, would be attracted not by the fact that he would make money on it, no, but by the fact that he would have some art on his walls by contemporary artists. Before that it was reserved to professional collectors, and these were a species of humanity, the same as dealers were: professional. After 1920, the people at large began to understand that they could buy.

CT: The present art market really started then.

MD: Yes, it was just after the First World War. A definite form of people thinking of buying for speculation. But at that time art was not a commodity, it was a fancy on the part of a certain group of people who were not professionally collectors but who were on the way to become collectors.

CT: You also organized a number of important exhibitions.

MD: Well, yes. There was the Société Anonyme. Katherine Dreier wanted Man Ray, Kandinsky, and myself as sort of vice presidents, to start that society, which she did in 1920. She rented an apartment on the ground floor on West Forty-Seventh Street, two rooms, I think, and that was the Museum of Modern Art at that time. And she made several exhibitions of my brother Villon. Of course there was no money. But it left an impact. And then after that the Surrealists started their careers, and it was only much later that I was involved with them, organizing shows. There was one at Wildenstein in 1937, where the ceiling was filled with coal sacks. That was a nice one. The room was completely dark, pitch-black, and to see the paintings you had to come with a flashlight, so flashlights were distributed at the door. And there was a big brazier with coals in it, like the kind they use to heat chestnuts; instead of coals we put an electric light underneath. That was the only light. But of course everybody would steal the flashlights.

CT: The coal sacks were your idea, weren't they?

MD: Yes. Yes, I liked the idea. There was another show in 1942 on Madison Avenue. There we put strings—it was supposed to be sixteen miles, of

course it only came to not even one mile. But I ordered sixteen miles. We had string in our pocket for years afterward. [*laughs*]

CT: What was the idea of the coal sacks?

MD: These ideas never had any direct rational explanation. If you wanted to be a Surrealist, that was one of the things to look for. This time we gave more importance to the ceiling, that's all. Anything that could bring out the meeting of two incompatible elements would be welcome. There was also an electric heater on which we put coffee grains during the exhibition, so that when you came into that show you'd smell the coffee first. The idea of introducing a smell was new enough then.

CT: Did you enjoy that kind of activity?

MD: Yes, it amused me. It was done with a spirit of real playfulness. And nice people. I mean at that time there weren't so many intestinal difficulties among the Surrealists—there was more cohesion. Now it would be impossible. Today the young generation takes it so damn seriously, so that Surrealism is getting to be a bore. It's too dogmatic in the mind of these young people. They are not inventive or imaginative; they use all the ideas they have seen or heard about, use them again in dogmatic form, and probably write books about it. [*chuckles*]

CT: You kept somewhat aloof from the Dadaists, but it seems you were more involved with the Surrealists.

MD: Well, at the time of the Dadas I was here in New York again; I was not in Paris except for a month or two at a time. I didn't take part in their manifestations. I never had the attitude of the ham actor, which you had to have to be a Dada, because you were onstage performing all the time, reading completely idiotic things. [*laughs*] And I hated any public appearance. Since then I've gained momentum in this direction, because I can lecture now, I can do things like that. I don't enjoy it, but I don't care. With the Surrealists it is not as stagy as it was—sort of immobile decoration, like that form of expression in the Surrealist shows. The last one was in New York three years ago at D'Arcy. Did you see it?

CT: No, I didn't.

MD: Well, the only thing I enjoyed very much there was the chickens. You see, in one corner we put three chickens—white, beautiful, beautiful chickens—that we fed all month before the exhibition. It would smell like hell for about a month after. Quite a bit of work. [*laughs*]

CT: What about chess?

MD: Until the First World War I only played to amuse myself. There was never any intention of taking it too seriously. Here, in 1916, 1917, 1918, I played a lot of chess at the Marshall Chess Club, on West Fourth Street or somewhere, near Washington Square. I spent quite a number of nights until three in the morning, living uptown at Sixty-Seventh Street and going back on the elevated. But that's probably where I picked up the idea that I could play a serious game of chess. I remember playing for the Marshall Chess Club, against another club. And also in Buenos Aires, where I went in 1918 for nine months, I joined a chess club there and spent my nights reading books and learning the tricks of the game. So when I came back to New York around 1920 or 1921, I was more or less involved in chess. To be one of the members I had to study up in the books, to be of the necessary strength not to be ridiculous. Which I did. After that, the ambition set in, and from then on you want to become champion of the world, or champion of something. And of course I never succeeded, but I tried, for twenty years after that I really took it quite seriously. I played in several French championships. Of course I never was champion of anything, but at least I was an enthusiast of it. And around 1940 I understood finally that it was no use trying.

CT: So you quit chess altogether?

MD: What happened then was that I started playing correspondence chess. You play with twelve people. They send you a postcard and you answer within forty-eight hours. So, every day, a postcard would come, with a move. And then you look up what your answer can be. One tournament would take a year and a half. Four and a half years for three tournaments. It was agony. You couldn't do anything else but wait for that postcard and prepare for the answer, because you could be penalized for not answering within the time limit. It was completely idiotic. [*laughs*] This was between 1930 and 1935. At the end I swore I would never touch correspondence chess again.

CT: Did you win any tournaments?

MD: I think I made ten German marks as a prize, for five years of work. I won one or two tournaments and received ten marks as a reward. Stupid.

CT: It sounds as though you have really devoted more time to chess than you have to art. I'm just wondering why it was possible for you to accept the seriousness of the chess world though it wasn't possible to accept the overseriousness of the art world.

MD: Yes, but you see, chess in that form took the shape of a real competition, man to man. It's a

competition between your mind and his mind. It's complete—there are no bizarre conclusions like in art, where you can have all kinds of reasoning and conclusions. It's absolutely clear-cut. It's a marvelous piece of Cartesianism. And so imaginative that it doesn't even look Cartesian at first. The beautiful combinations that people invent in chess are only Cartesian after they are explained—in other words, you cannot see them coming at all. And yet when it's explained there is no mystery. It's a pure, logical conclusion, and it cannot be refuted. The attitude in art is completely different. Probably the two things pleased me because they opposed one another—the two attitudes—as a form of completeness. And I was not on one side any more than on the other side. I don't know, I'm giving you explanations that I never thought of before now. You don't know why you breathe, after all.

CT: Of course, there is competitiveness in art also. I'm sure some artists feel in competition with other artists.

MD: I find that so stupid. There should not be any competition. I mean there is nothing to compete for except the money. It's just a form of disguised envy, don't you think?

CT: I think. I don't know very much about chess. But critics have been...

MD: There was no money in chess either.

CT: No?

MD: No money. You could be a professional in chess, but only very, very strong players survive. Even in Russia they have no professional chess players. They all have professions besides their chess activities, which of course the government in Russia helps with. Here chess is absolutely ignored by officials. There is no help at all. The American federation is so poor. And there's no money involved for the men who lose.

CT: Is there such a thing as personal style in chess, anything that could be comparable to what you're talking about in painting?

MD: Oh, yes, indeed. There are schools of chess. The Romantic school. They have even the Hypermodern school. It's a very amusing name they invented. And the new schools oppose the preceding ones. But after all, it's more a speculation of the mind and hardly in danger of being spoiled by money. I mean, art is definitely spoiled by money today, isn't it? Spoiled or enhanced? I don't know. [*laughs*]

CT: Do you play as much as you did in the 1940s?

MD: No, I don't play anymore. Being able to play

well diminishes with the years, you know. And even the champs can't play like they used to. They finish about age sixty, sixty-five.

CT: Returning to art, have you had close friendships with artists?

MD: Never very close friendships. I'm very friendly with them, and they with me, no question about that, but there's no real bond. At one time it was Picabia. Picabia was a close friend, the only one in 1910, 1911, and 1912. I've never been a bond-ish man, because I don't believe in talking. Here we have been talking for hours! But don't believe what I say.

CT: Then this might be a good time to ask you about the *Show* magazine interview last year, where you spoke of the present period as being the lowest point in the history of art.

MD: Well, there is no low and high, actually, but I'm afraid that our dear century won't be very much remembered in five more centuries from now. As compared with the nineteenth, it will be sort of eighteenth century–like in value. The eighteenth was considered a frivolous form of art, light form of art, more or less decorative. I wouldn't say decorative for the twentieth at all. But it has no durability in the making of it. The means employed to produce art are very perishable. They

use bad pigments; we all did. I've done it my-
self. So that in a short course of time those prod-
ucts will disappear. Now I think paintings peel
off all the time. They are repaired and restored
constantly. And the restorers of course partly de-
stroy them by restoring too much. When a paint-
ing peels, you have to paste the peeling on again
and it brings another touch to the painting. Even
my Glass is a perishable thing because it breaks
easily, but if it breaks you protect it, and the fact
that it is broken is not detrimental, since you ac-
cept it, you forget the breaks, and you see what
was behind the breaks. But the general feeling
about it is—quick art.

CT: Yes, art for the moment.

MD: Art for the moment, which doesn't care about
the future or the past. That I think has been
characteristic of the whole century, from the
Fauves on. And as a result, slow work is consid-
ered bad: you must do a painting at the most in
an afternoon. Otherwise you're stupid. I mean,
you are not considered important at all. And
that is, for me, a thing I can't admit. I think
there is a great deal to the idea of not doing a
thing, but that when you do a thing, you don't
do it in five minutes or in five hours, but in five
years. I think there's an element in the slowness
of the execution that adds to the possibility of
producing something that will be durable in its

expression, that will be considered important five centuries later.

CT: In that sense your own work could be said to be in conflict with the spirit of the century.

MD: Yes, because I produced so little, and everything I produced took me quite a long time.

# II

CT: You've said that the *Coffee Grinder* is the key to all the rest of your work. I wonder if you'd elaborate on that.

MD: Yes, but I did not intend it to be that way. You never prepare things like that. It happened at the end of 1911. My brother the sculptor, Duchamp-Villon, asked me to make a little painting for his kitchen. It's probably normal today to have paintings in your kitchen, but at that time it was rather unusual. He asked Gleizes, he asked La Fresnaye, he asked Metzinger, five or six of us, and he gave us the size of the paintings because they were to go above the sink. So I just had the idea of making a coffee grinder, just to be close to the subject. As it turned out, instead of making an objective, figurative coffee-grinding machine, I did a description of the mechanism. You see the cogwheel, and you see the turning handle at the top, I also used the arrow showing the direction in which the hand turned, so you see there's already an idea of movement in that, plus the idea of composing the machine in two parts, which is

the source of things that came later, in the Large Glass. I always liked that painting.

CT: Your own work, in a sense, can really influence what comes later.

MD: Yes. Later, I used many, many of these little details. Even the arrow, with a dotted line, something I'd never used before. You also see the coffee after it's ground. It's not one moment; it's all the possibilities of that grinding machine. It's not like a drawing. It was a determining factor in my development at that time, but I didn't know where I was going at all; I was just making a present for my brother.

CT: Did you have any thoughts about the machine being characteristic of the time?

MD: Yes, they call it the machine age, don't they? I mean, everything is becoming mechanized in this life. All this creates a climate for my being attracted to expressing myself in the form of mechanographic, if you want to say, instead of using the old-fashioned approach of the painting. I was interested in using a mechanistic approach, if I wanted to step out of tradition.

CT: And into something new?

MD: New enough.

CT: Could we talk some more about this idea of stepping out of tradition?

MD: I suppose it must be the attitude of anybody who wants to find something of his own. To do something of your own you've got to forget what you've learned. And once you begin forgetting, you're bound to find something...else. Of course, you can try and never succeed. You think you're doing something entirely your own, and a year later, you look at it and you see actually the roots of where your art comes from without your knowing it at all. Well, there was nothing psychoanalytic about it, that I can tell you. I'm not conscious of any reason, except the reason that you've got to find yourself, if you have a self to find. I suppose after forty years, you can see the self that you were. But at the time, I was too immature to know what I was doing. That's always the difference between the time you do a thing and the time after, when you discover that there was something entirely new in it. Even *Nude Descending* was not new to me when I was doing it. I didn't know. Only later, I found out by the reaction of others that it was new.

CT: I didn't mean anything psychoanalytic, I just wonder if when you were a child you had the same sort of tendency.

MD: You mean to play games that were not played by

others, or something like that? Yes and no. I was
a very normal child. I passed my baccalaureate
at seventeen. Not well, but I passed. The same
with my military service. Instead of waiting until
I was twenty-one to be a soldier, which was re-
quired then, I decided to do it at age eighteen.
At that time there was a law that lawyers, doc-
tors, and another section called workmen of art
have a chance to do only one year of military
service, if they pass an examination. I was not a
doctor or a lawyer, but I could be a workman of
art, which I did by passing the examination. My
grandfather had made a good many etchings,
the father of my mother. I passed the examina-
tion brilliantly and was given the right to spend
only one year in military service. A year later an-
other law was passed, that everybody had to do
two years of service, instead of one or three. But
that was only a side of my character, to get rid of
these examinations and diplomas as quickly as
possible when you are forced to take them. Not
to evade it, but to get the quickest way through
the accomplishment of what I had to do, to get
rid of it.

CT: Something else that I want to ask you about is
the whole aspect of chance, which you were in-
terested in quite early. At what age was it that you
wrote that piece of music by chance methods?

MD: It was 1913, I think. That had to do with the

readymade, after all. It was in 1914 that I did *Pharmacy*. *Pharmacy* was the landscape. You have seen it, right?

CT: Is that the first readymade?

MD: No, no, no. It was one of them. I mean it was at the same time as *Bottle Rack*. It was the year after the *Bicycle Wheel*. All this was together, you see. The chance piece was around the same time, between 1913 and 1914.

CT: What was your interest in chance?

MD: Nothing much more than to get away from things already worked out. A real expression of the subconscious through chance. Your chance. If I make a throw of the dice, it will never be like your throw—meaning that it's a marvelous expression of your subconscious. And so an action like throwing dice to find the notes of a piece of music was nevertheless a subconscious expression of myself.

CT: John Cage has always used chance as a means of getting *outside* his own personality.

MD: Yes, so he doesn't control with his mind. That's what he wants. Chance is the only way to avoid the control of the rational.

CT: And John has primarily used it as a means as getting outside of his own personal expression, outside of his own subconscious, even. But what part of you enters into a chance operation?

MD: Chance is a thing that people have and don't have. Bad luck or good luck—in general, bad or good is the property of each individual. What Cage would do by chance isn't like what the next man would do. He explained it, as you say, to avoid the control of his rational approach to things. In other words, he was not responsible for what happens externally, but internally he was.

CT: It's possible.

MD: He may give another explanation, which sounds more plausible to what he is doing. But whether it's his chance or my chance, it doesn't matter, it's still chance primarily.

CT: Yes. Except you feel that chance, if you use it, is somehow an expression of yourself.

MD: Yes, of myself.

CT: I don't think he would feel that.

MD: The production is not controlled, but the fact is he chose chance to make it. And what he would do by chance wouldn't be what the next man would do by using chance.

CT: That's true.

MD: Isn't it?

CT: Yes.

MD: So the duty of chance is to express what is unique and indeterminate about us beyond the rational.

CT: In your mind, chance is a rational expression of avoiding the control of your mind.

MD: Absolutely. And interestingly, the basis of the readymade, you see, in a way.

CT: Well, when you first did the *Bicycle Wheel*, was there any particular idea in your mind?

MD: No, there was none.

CT: So how did it come about?

MD: It was just a pleasure to have it in my room. It was interior decoration, a pleasant gadget.

CT: I see.

MD: It was also pleasant for the movement it gave, like a fire in the chimney, moving all the time. Probably the source of the idea of movement was there, I'm sure.

CT: You then selected it for aesthetic purposes?

MD: No. Aesthetic in the sense of interior decoration. [*chuckles*] But not really aesthetic in fact.

CT: Pretty, but not as art?

MD: No.

CT: But because it was unattractive?

MD: Plus a little derision, too, because humor played a great role in my life, my God.

CT: Yes. [*laughs*] And then, as you selected more readymades, did you acquire more of an idea about the readymade by collecting them as a whole?

MD: Oh, yes. Have you seen that paper that I read at the Museum of Modern Art? It is a very short thing.

CT: I don't think I have seen that.

MD: I'll find it and give it to you. It's about how the choice of the readymades never was a result of aesthetic delectation. In other words, they were not chosen because they looked nice or were artistic or in conformity to my taste. And that was the difficulty of choosing something, because the minute you choose something, gener-

ally, you are valuing the artistic facets of it or aesthetic essence of it. But that is not what the readymade was about. So that makes the selection much more difficult, because you can't help but choose things that please you. But that's just another rule you find on the same seashore. That is nothing at all, far from it. And the fact that manufactured objects had the advantage of being repeated, that there was an edition of it made by machine, added to the impersonality. The danger of that is that you have twenty thousand readymades a year. The danger would be to direct it toward a taste. Tasty affairs. You could be taken in by the readymade idea to become an artist again. A tasty artist, choosing more and more. Which gave me the idea of defining art as a habit-forming drug. And through the readymade I could avoid that. Art is a habit-forming drug, that's all it is, for the collector, for the artist, for anybody connected with art. It has absolutely no existence as such, as veracity or truth of any kind. As a form of definition I'm delighted with this. I'm very convinced of it. So in the readymades I avoided that, by not choosing them too often. There are only ten of them in my whole life. I could have been completely taken in by the idea.

CT: You didn't really repeat very much of anything in your life. There are very few paintings either.

MD: Well, yes. I could have distorted the idea of the

readymade by repeating it every minute. It would have become a form of art of that thing I call a habit-forming drug.

CT: Do you see this as something pernicious?

MD: No, no, but when people speak of art on a very religious level, I try to explain to myself that it is not much to be revered. It's a drug. Like religion to the Russians. And I'm more and more convinced of that.

CT: There's been so much written about the readymades being a protest against art as a commodity. Would you prefer to consider art as a form of magic?

MD: The more I go on, the less I find any possibility of it. There is this dilemma, as I have said, that the onlooker is as important as the artist. There are two poles, the artist and the onlooker. If there's no onlooker there's no art, is there? The artist looking at his own art is not enough. He has to have someone to look at it. I give to the onlooker more importance than the artist, almost, because not only does he look, but he also gives a judgment. I think this is a way of bringing the unimportant play of art in society. It's a little game between the onlooker and the artist. Like roulette, or like a drug as I said be-

fore. So the magic part of it—I don't believe in it anymore, I'm afraid I'm an agnostic in art, so to speak. I don't believe in it with all the trimmings, the mystic trimming and the reverence trimming and so forth. As a drug it's very useful to many people. It's a sedative drug.

CT: What about some of the traditional things that an artist is supposed to do, such as the idea of self-expression on the part of the individual artist being relevant to the general unexpressed state of affairs and thus leading people into a deeper awareness of their life?

MD: Like aspirin or something for the headache of life? [*laughs*]

CT: An intensifier.

MD: As a drug, it's very useful for many people, it's true. It's a sedative for that life we lead.

CT: Is it a drug for the artist, too?

MD: Oh, yes, but differently. There's the psychological aspect, of setting himself on a pedestal. The artist does anything to think that he's going to be part of the Louvre or the Metropolitan. Using art as a stepping ladder. That's another chapter of life, the chapter of ambition. But you have that in business, too. You have that everywhere.

CT: Your definition of art in a way comes close to what Matisse said about art being like a comfortable armchair.

MD: Well, yes, in the sense of a drug, it does. Sure, it has all these advantages. But at the same time you must not give it the reward of being sort of religion-like. It's not even as good as God. [*laughs*]

CT: How long ago did you come to this conclusion?

MD: Well, little by little, I don't know how it came exactly. It doesn't take the form of a very important conclusion because it doesn't change anything. Art is one of the activities, no more than that.

CT: You've made a distinction between the works of art that go into art history and the works that are still alive.

MD: That's a little amusing idea, but I don't know whether it has any foundation. After a work has lived almost the life of a man—twenty or forty years, it doesn't matter the number of years—comes a period when that work of art, if it is still looked at by onlookers, is put in a museum. A new generation decides that's all right. And those two ways of judging a work of art certainly don't

have anything in common, in my opinion. That's why I say the life and death of a work of art—death meaning posterity, meaning art history.

CT: You must have an interest in art history, because of your meticulous reproduction of your work.

MD: Yes, it had been my occupation. But as I told you, it's not my concern to decide whether it's art—I made the art, I'm the artist, who has absolutely no inkling of what he's been doing.

CT: What did make you want to reproduce your work?

MD: I don't know. I sold the things, I made money—part of it was business. Small business, I can assure you. No, there was no reason. Except that, having a small production, it was easier to do it than if I'd had the rate of a painting a month, or something, like Dubuffet. In my case it was fun, for me, having a small production, to make it into a group more expressive of one's life.

CT: Was that more interesting to you than making something new?

MD: Well, I didn't want to do anything new. I'd had enough. The minute you systematize anything… If I had systematized the readymades I could have made a hundred thousand readymades in ten years, easily. They would have been fake, be-

cause they would have been quick, easily chosen, and then regretted a year later. I would be compromised. [*laughs*]

So when people find something interesting in what I did, and then use it as a system, I have my little doubt about it. At least I'm conscious of the danger. Anything systematized becomes sterile very soon. There is nothing that has eternal value. It's according to the way society takes it. The poor *Mona Lisa* is gone because no matter how wonderful her smile may be, it's been looked at so much that the smile has disappeared. I believe that when a million people look at a painting, they change the thing by looking alone. Physically. See what I mean? They change the physical image without knowing it. There is an action, transcendental, of course, that absolutely destroys whatever you could see when it was alive.

CT: You mean it deteriorates in a sense?

MD: Deteriorates. Sometimes it's an embellishment. With El Greco, for example, it became a rebirth a hundred years ago. He had been buried long ago, two or three centuries. All of a sudden, he was put up again. But he will probably deteriorate again after two centuries of admiration. You see what I mean?

CT: This is different from the process by which peo-

ple have heard so much about a painting that they no longer see it?

MD: It's both. But I will go further and say that there is a physical action of the onlookers. The onlooker is part of the making of the painting but also exerts a diabolical influence by looking alone. The same thing with my damn *Nude*, you see, from a scandalous painting it became a boring painting, by being looked at so much. "Oh, that's the *Nude* again." [*laughs*] It's detrimental to the poor thing.

CT: But has it changed in your eyes now from having looked at it?

MD: No, because I'm not an onlooker. I can be an onlooker sometimes, but I can also avoid being the onlooker because I see things as I saw them when I was making them. It is another form of looking.

CT: What about this whole mystique of the object in art?

MD: I don't know. It's very curious because it's one of these words that has no meaning to begin with. An object is an object, a three-dimensional form. But words are taken and repeated, and after a certain number of repetitions the word takes on

an aura of mysticism, of magic. And it goes on because men love to do that. They imagine the object as being something phosphorescent or something. That's what happened to the word *object*. But the minute you have a number of believers, then anything goes. You can do that with anything, you can create magic with anything, but it has to be done without preparation.

CT: You think it was primarily because of the repetition of the word itself?

MD: Like publicity. All along it's the same thing, like the idea of repeating, "Coca-Cola, Cola-Cola." After a while magic appears around Coca-Cola.

CT: It gets fixed in your mind.

MD: Yes. And maybe in fifty years, if nobody speaks of Coca-Cola again, it will disappear, like the idea of how art should die after a time. Time will take care of all these crazy notions people invent, and forget all these marvelous magicians. [*chuckles*]

CT: Do you feel like what constitutes new art today like the Pops is more Coca-Cola than say, Cézanne?

MD: You see, as much as possible I never try to judge or criticize anything. When you see something

that you haven't seen before, like this Pop art—
and I'm talking about myself now—I would never
think of judging or deriding or criticizing be-
cause what can you prove with your words? The
words you use making fun or making judgments
have absolutely no value. They are just taunts, a
pack of words. At least with a painting it's there,
or the thing is there in flesh and you do what
you want with it. Just turn your back to it if you
want but don't bother writing about it or think-
ing about it.

CT: But don't you feel you have more of a rapport
with the work of newer artists like Rauschenberg,
who has a certain amount in common with...

MD: Oh, yes, of course there is a great deal of rapport
with Rauschenberg. When I first saw it, it was a
great pleasure. There was a favorable exchange
of feelings, which is much more important than
criticizing something. Even if you make a mis-
take by liking something that you shouldn't, for
whatever reasons, there's much more to love
than in hatred. [*laughs*] I mean, what's the use
of hating? You're just using up your energy, and
die sooner.

CT: Do you recognize some of your own ideas or pre-
occupations in the work of Rauschenberg?

MD: Yes, vaguely. But it's not important, because it's his own development that makes Rauschenberg into something. I mean, when you can, you must use whatever you find in your life as a basis to go on from.

CT: But how does it feel to have so many of your ideas now seem like prophecies and to have them adopted by so many of the younger generation?

MD: There's a little exaggeration in that, but anyway, it is probably due to the fact that I, with my Cartesian mind, refused to accept anything, doubted everything. So, doubting everything, if I wanted to produce anything I had to find something that gave me no doubt because it didn't exist before. Having invented them there was no doubt about them, ever. [*laughs*] All along, I had that search for what I had not thought of before. When I had done one *Nude Descending a Staircase* I would not do another one.

CT: It does seem as though a large number of people are using things of yours as a basis.

MD: It may be that these things that I had done, not coming from anything before me, might be a source for these young people to start, a new step, which I accept with pleasure. That's all I can say.

CT: Whom, besides Rauschenberg, do you find particularly interesting?

MD: Johns and even some older folks. The only thing is, I don't object to it, but I mean, to put it in balance, the fact that they do it so fast, and so many one-man shows, it's just like a boom.

CT: With so much money.

MD: So much money involved and so much eagerness. We can't, of course, compare two periods that are fifty years apart. Still, it was not the fashion to be so fast in my time. [*chuckles*] It's not an objection, but it's a difference.

# III

CT: Motion is an important element in your work. How did you first get hold of the idea? Did it come from the Futurists?

MD: Well, it came at the same time, sure, but you see I never was aware of the existence of the Futurists in Paris at that time. They were in Italy. I was very young, and even with the French painters of my generation, I hardly knew them. In 1910, I was twenty-three, and I had done some drawings for the illustrated papers *Le Rire* and *Le Courrier français*, to make a few pennies, because I did not know what I wanted to do at that time. You do not know at twenty what you are going to do at forty. Of course at the age of fifteen I did some landscapes at the country place where I was with my father and mother. But the idea of movement, I don't know how it came. Somehow it arrived in 1911, when I did that portrait of a woman—it's five figures of the same woman, repeated like a bouquet.

CT: I know that work.

MD: Three are the same woman dressed, with a hat, and the two others are naked. I never saw the woman closer than ten meters, but I met her on the Avenue de Neuilly, I was interested in her walking her dog or something, and I began that portrait. That was the first picture of the expression of the idea of motion. But it was probably subconscious more than actually a program.

[*silence*]

After that I did some chess players also. It was more or less the repetition of the profile of my two brothers, who were chess players. It was more a technical study, in the sense that I painted by gaslight, which was an experiment for me. Instead of painting by daylight or sunlight, I wanted to do it by gaslight. It is a greenish light, meaning that when you look at the same painting by daylight the next morning, you see a difference in grayish tones, the whole thing is subdued, it's no more the violence of the Fauve. And it was my first contribution, more or less, to Cubism, in 1911.

CT: Then came the *Sad Young Man on a Train*?

MD: Yes. That was October 1911 or November '11.

It was on the occasion of a train trip from Paris to my family in Rouen. And of course the sad young man on the train was myself. There isn't much of the young man, there isn't much of sadness, and there isn't much of anything in that painting, except a Cubist-influenced painting. My interpretation of Cubism was sort of a repetition of parallelism of some kind, of schematic lines without any regard for anatomy or perspective in a way. A parallelism of lines describes movement in a way, by repetition of the different positions of the person. That was the first, and after that came the first studies for the *Nude Descending a Stair* at the end of 1911. There is one study in Philadelphia showing still a very—not very, but still almost naturalistic nude descending a staircase. Naturally it's exaggerated, but at least it showed some parts of flesh. [*laughs*]

The first sketch for the *Nude* was a little drawing, handmade for an illustration of poems by Laforgue, whom I liked as a poet even though he is misunderstood, even today. Poets don't care for Laforgue. They say he's a second-rate poet. Anyway, as an illustration for that poem I made an ascending nude, just a vague, simple pencil sketch of a nude climbing a staircase. Probably by looking at it gave me the idea: why not make it descending instead? Meaning that if I was going to do a large painting based on

the sketch, I thought the majesty of descending would be more apt to help my static expression than ascending, you see? Ascending, as a form of effort, would be an entirely different point of view. While the descending would be majestic, like, what do you call it, in the theater, with those enormous stairs in the center?

CT: The musical?

MD: Yes, musical comedies. It took me about a month to finish it. It was sent to the Independents in February 1912. I already had some contact with Gleizes and Metzinger, because we had had a group show together in November 1911. I was one of them, supposedly—with Léger and Gleizes and Metzinger. It was different from the group of Picasso and Braque, who were living in Montmartre. There was no contact with them at all. So, when I sent it to the Independents—of course, no jury—they had a Cubist room, but when they saw my painting, before the show was open, they looked at it and decided it was not quite in accord with their theories. They already had Cubist theories. For them, Cubism was essentially static. The idea of movement, of a woman coming down stairs, did not appeal to them at all. And maybe they knew that the Futurists had been doing that kind of thing at the same time. I didn't know it, and they hadn't shown in Paris at that time.

CT: And you hadn't read their manifesto…

MD: No, I hadn't seen that. So they decided to send my brothers to ask me to change the title at least. My brothers came and told me the story. It was a little disconcerting for them. I said nothing to my brothers. But I immediately went to the show and took the painting back home. It's in the catalog of the Independents of 1912, but it never was shown. I didn't discuss it with anyone, but it was really a turn in my life. I saw that I would never be very much interested in groups after that. I felt it was too much of a schooling and a school, to say you must do this and you must do that, very much of an academy attitude.

CT: Did you show the painting anywhere else?

MD: It was shown six months later, at the Section d'Or. Another show that was organized mostly by Picabia, who had found a gallery on the Rue La Boétie. It was a very good show. In fact, that was where I met Apollinaire. I had never met him before. He came to the show. He was writing his book called *Les Peintres cubistes*. And that summer of 1912 I had been to Germany for three months. I was in Munich. It was my first trip out of France as a young man. Apollinaire had seen Picabia quite a bit, when he organized that Section d'Or show. Apollonaire wrote to me in Mu-

nich and asked me for photos of myself, for the book. But our first meeting was in October. That was about all, because from Munich on, I had the idea of the Big Glass. I was already finished with Cubism, and, if not with movement as such, at least it was not to be mixed up with oil paint.

CT: Well, certainly, it was an important aspect of your thinking from the early period.

MD: Oh, yes, absolutely. Imagine, in a world like the world of Fauve, the world of the early Cubists like the landscapes of Picasso and Braque of 1909 and '10, nobody had an inkling of describing movement at all.

CT: It was static.

MD: Completely static. They were proud to be static, too. They kept showing things from different facets, but that was not movement. It was, more or less, sort of a four-dimensional idea of seeing all the faces of an object at once. So I went on. The first thing I did in the direction of the Big Glass was the *Chocolate Grinder*.

CT: In which there is movement?

MD: Well, yes, but not expressed. We know it should turn, but it was not trying to express the move-

ment of that chocolate grinder at all. I did two paintings, and the second one is made in an architectural way. The rollers, their shape is indicated by parallel lines indicating their shape, not their movement. There was no intention to describe movement as there was in the *Nude*. I was finished with movement as such. Except that I had different ways of doing movement, for example the first readymade I made was in 1913, with the *Bicycle Wheel*. I mounted a wheel on a stool and that was it. [*laughs*] Remember, though, it was not called a readymade then. They became readymades two years later, by the fact that I discovered the word in 1915. It was an idea; to have it in your own place the way you have a fire. It was not intended to be shown, to be seen. It was just for my own use, the way you have a pencil sharpener, except that there was no usefulness to it. It was completely *un*-useful.

CT: Did you continue making readymades after that?

MD: Not really. After the *Bicycle Wheel*, I began to think of how could I do something that would not be painted on canvas. I was already bored with the idea of painting on canvas. For me, canvas and oil paint were the instruments that had been so abused in the last nine centuries, I wanted to get away from it, to give myself the chance of expressing something different. The Glass idea came then. I bought a piece of plate glass.

I had already designed the idea of the *Glider*. So I bought the glass. And in order to draw on the glass, the first idea was to use fluoridic acid. To engrave on glass you use fluoridic acid. And I began buying paraffin to keep the acid from attacking the glass except where I wanted. I tried that for two or three months, and it made such a mess. Plus the danger of breathing in those fumes, I saw I couldn't go on very far with it. It was really dangerous. So I gave it up. But I kept the glass. And then came the idea of making the design, the drawing, with lead wire, very fine wire that you can stretch to make a perfect straight line. It was very malleable material, which was lovely to work with. It doesn't resist your intentions. So that pleased me. Before the idea of the Glass came I had used a piece of glass for a palette, you see, and I looked at the color through the glass, and that gave me the idea of protecting those colors from oxidation. If you protect them, there wouldn't be any more of that aging of the colors, which is true in all paintings. You know, after ten years they turn yellower and so forth. So that was one of the tricks of mine, to use that, and it made me decide to do a painting on glass, from the back. Paint on the back of the glass. And the lead wires would be put down with varnish. You put it flat and put down your shape exactly and put on a drop of varnish, and it holds. It has held for forty years—but I don't promise anything for two centuries! [*laughs*]

All along, I had been thinking of the name of the painting. I had made a bride in Munich. It was on the abstract side of the fence. There was no bride, just working in an abstract way, to let things come onto the canvas as they pleased—an abstract form of expression. I extracted from that painting the form that I wanted to use in the big final Glass. All this had to be planned and drawn on paper beforehand, like an architect. I made a little drawing first where everything was measured. On my plaster wall I had in my studio then, I drew in pencil the final shape, the exact shape, of what the Glass would be. Not any old way or at random at all. This was all to be on a certain place, in perspective, using regular, old-fashioned perspective. All these things amused me a lot because it was so far away from the Fauves and the Impressionists and the Cubists.

[*silence*]

At the end of 1914, when the war broke out, I had finished this and the other one. These studies, call them what you please, were already to be placed exactly—I had every measurement, with the reductions, to place them in the glass. So when I arrived in America in 1915, I brought this thing, this *Moules Mâlic*—I didn't bring the semicircular glass, I had given it to my brother in the country. But I later sold it to the Arensbergs and had it come here; I made an exchange

with my brother. And then I began immediately in 1915 on the Large Glass. I bought two big glass panes, and I started the top, the *mariée*, and I worked at least one year on that. And then in 1916 or 1917 probably, I worked on the bottom part: I worked on the bachelors.

CT: What was it that took so long?

MD: My laziness. I couldn't work more than two hours a day, maximum. It bored me stiff. [*laughs*] It interested me, but not enough to be eager to finish it. I didn't care. I had no intention to show it or to sell it at that time. I was just doing it: that was my life. And whenever I wanted to do it I would. That's my makeup, I can't complain. It was tedious work, you see. Even today I can't work more than two hours a day. It's really something to work every day. I can't explain it, and I don't want to say it's the best thing to do. But at least it was in my case. There's a copy of the Big Glass made in Stockholm. You've heard of that?

CT: I've heard of that.

MD: It took the man who did it six months! And he probably had helpers around. I never had anyone but myself. Everything was done by myself, and I didn't care how long it took. Anyway, it was never finished until 1923, because I went back to Europe in 1918, and then Buenos Aires, and

then came back in 1919. I worked on it again for a year, but then took two or three trips to Europe, because I was only on a temporary visa and I could only stay six months at a time. And finally in 1923, I gave it up altogether. I didn't finish it. There are parts in the drawing that are not on the Glass. I became bored with it. I said, "What's the use of going on?" I'd had enough.

[*silence*]

Then in 1926 it was in a big show in Brooklyn. And on the way back to Miss Dreier, it was broken. It was packed flat on the truck, in a box, and the truckmen did not know what was in the box. They were bouncing it sixty miles to Connecticut. And Miss Dreier did not know until some years later that it was all broken. I said I'd come back and fix it someday, and I did in 1936. Two months in her place, in West Redding, Connecticut. I made a studio in her barn. The pieces were not scattered, they were kept in their place. So I fixed it using two more panes and a frame holding everything up. My life has been very much connected with broken glass.

CT: Broken glass. What were your feelings when you heard it had been broken?

MD: Nothing. Not much. But I had to console her. I have a fatalistic attitude in general. I never cry

for anything that is unpleasant, and I said to her, "To hell with it." Broken glass was not the newest thing in my life. And after all, it had no value in the artistic world at that time. Nobody cared for it, nobody saw it, and nobody knew about it because she had it at her place, and it was never shown anywhere except in Brooklyn in 1926. But we remember today.

CT: Getting back for a moment to the subject of motion, you say that you are not, in the Large Glass, interested in describing motion in the sense that you were in *Nude Descending.* But it did have a good many elements of motion, of things like the dazzling of the splash and the shots. Do the details in the Large Glass express your ideas about motion?

MD: Well, of course, I still was interested in movement, but not in the same way. And those things are not indicated in the Glass at all. But they are in the book about the Glass. They are the things that happen without being seen. The splash and all that are not pictured, are not described pictorially. The Glass and the book are very much connected. Not only connected, they are made for one another. My first idea, when the Glass was finished, was to have that book made like a Sears and Roebuck catalog, explaining every detail of the Glass. An explanation describing in

literary form what every piece and every section of the Glass was done for. I wanted it as dry as a Sears and Roebuck catalog. That was my intention. I never did it, except that it took the shape of the *Green Box*, which is especially made for the Glass. But not enough of it, it should have been twice as big, with many more details. It was the beginning of what I wanted to do.

CT: The preoccupation with motion continued with the rotary machines.

MD: Oh, yes. That was in 1920. I can't remember how it came to me. They never show it because it's too dangerous, and also it's fragile. Those plates, with lines, make circles when it turns. And that probably gave me the idea of smaller things turning. The main point is that, I'd noticed that when two circles with different centers are on top of one another and are turning on a third center, so that they each have a center and a third center between the two centers, one of the circles will go up and the other will go down. You don't know which: it depends on your eyesight. It was a phenomenon that amused me very much then. In other words, the third dimension is created there, right there, by the circles turning on a third center. From then on I did some designs and many drawings for the movie called *Anemic Cinema*. I made a movie of that idea. But

in 1934, some ten years later, I discovered that I could make designs. Instead of making abstract designs like *Anemic Cinema*, I could make forms that could re-create objects, by putting three or four circles on top of one another, on another center. So I did those twelve drawings in 1934 and made an edition of it by printing them on cards. But then I showed these things to a sort of scientist, an optics physicist. He said, yes, this is very interesting because we have special designs to bring back the feeling of the third dimension through one-eyed men. When people would lose one eye through an accident and lose the ability to see in the third dimension. Of course there was no interest in the artistic world, but for me it was very important.

CT: You tried to sell them once?

MD: Oh, yes. There was a thing called the Concours Lépine. Lépine was a prefect of police in Paris for a number of years, and he had created a salon for inventors and gadgeteers. Near the Porte de Versailles. Very important. All the inventors went there and set up a stand. What do you call it, stand or booth?

CT: Booth.

MD: And for a whole month, they sold their goods there. So I did the same thing. I had a secretary,

too, because I didn't want to stay there all day trying to sell one. I sold them for eighteen francs. I had three of those machines turning three at a time to attract the populace. They never bought one! One was sold in one month. [*laughs*] It was a complete fiasco.

CT: Did people look at them in passing, or did they just walk away?

MD: Oh, sure. There were children everywhere. It was a very popular center. There were many gadgets for sale, for your kitchen or bedroom. Very good prices too. It was a very funny experience.

CT: Have you any idea of why this preoccupation with movement has been with you for so long? Do you have any ideas of its relevance to the present time?

MD: It is probably the consequence of the modern world, which is based on motion. After all, it used to take five hours to go from Paris to Rouen, now you go in ten minutes to the place. Speed and motion have been the most important chapter of the modern world, isn't it? The expression of man has been toward more and more speed.

CT: But how does that apply to art?

MD: It is a sort of climate in the world today, and the

artist had to follow—to introduce it. Why keep the static idea in art? It wasn't necessary at all. And it was not an anti-artistic form of expression, to introduce movement. But I felt I had to express the idea of movement as an aesthetic feeling, in a way that the static painters before didn't. I think the definition of art was more or less static all along, all these centuries. Introducing the idea of movement in art was the discovery of our century. That is my impression.

CT: All ideas have to change.

MD: Yes. The Futurists really were for that reason much more of their own time than the Cubists. The Cubists were old-fashioned static painters. Even the cutting into facets was a timid form of breaking out of rules.

CT: Was there a feeling of rivalry, do you think, between the Cubists and the Futurists at that time?

MD: Oh, enormous. It was not even a rivalry. It was plain disdain on the part of the Cubists. You see, the Cubists were still old-fashioned painters who spent their days painting and had no idea what was going on around them, just plain toiling every day. Whereas the Futurists were men of the world, they knew what was going on. At the time I didn't know the Futurists because I was too young. But then I hardly knew my Cubist friends at that time.

CT: Were you interested at that time in aspects of technology that were going on around you?

MD: No. It was a matter of applying to art of the time—Cubist and Fauve and Impressionist—something that was not ever thought of by these fathers. I wouldn't want to copy an Impressionist painting, or use their tricks or their theories like the simultaneism of Seurat. That didn't interest me. I wanted to find something to escape that prison of tradition. Tradition is the prison in which you live. How can you escape from those pincers?

CT: Most artists have been content to make do with tradition.

MD: Well, then, they go on with it, but when they are ready to be themselves, things hold them down in spite of themselves. The education is so strong in every child. It holds them like a chain. That's what I wanted to avoid, and yet I didn't completely get free. But I tried to, consciously. I unlearned to draw. I actually had to forget with my hand. With my paintings around 1910 it was already unlearning, or learning how to forget. There was also systematic distortion, which was my way since 1900 and probably before that even. In the case of Matisse, I'm sure he had to decide to systematically draw differently from what he had learned in school.

CT: Something I've been wondering about is your general attitude toward science. Isn't your own work influenced by science?

MD: No. Ironically, yes. It's an ironic way of giving a pseudo-explanation of it. I don't believe in the explanation, so I have to give a pseudo one: pseudoscientific. I'm a pseudo, all in all. [*laughs*] That's my characteristic. If I used the little mathematics I knew, it was just because it was amusing to introduce that into a domain like art, which has very little of it generally. Even the idea of perspective was a sort of forcing myself to be at the service of a scientific idea, to get away from the free hand, as I often said. I had to get out of that pattern, you know, that splash on the canvas and everything like that. Perspective forces you to give a shape to any object you draw by the laws of perspective. So, your chocolate grinder could be drawn freehand, with two instead of three rollers, or one upside down, as the Fauves might have drawn it. But when I came to do my *Chocolate Grinder* I used perspective to design it, so that the form wouldn't be dictated by my taste at all. It was forced on me by perspective.

CT: I see. You're using science in a way as a means to art.

MD: Yes, to avoid other things. It was a game.

CT: You've talked about stretching the laws of science, and I wonder if this is spoken about in the same spirit as you trying to break with tradition, to avoid what feels inevitable.

MD: Well, it's easy to say but not so easy to do. It's a very interesting thing to decode whether something is a law. It's a bit tautological. We have to accept it, as we see it coming at us by the same repetition of cause and effect. So, being caught in causality, there's no way out. But that doesn't mean anything by way of the validity of it. It's just an illusion of causality. I've never believed in causality. Because you light a match and see a fire you consider that a law. It's a very nice word, *law*, but it has no deep validity. That's what I think. It's just a habit.

CT: One of nature's habits?

MD: Yes. What we don't know of it probably is not habit. What we know is just the limited perception we have of these happenings and facts. We are so fond of ourselves, we are little gods on earth. I have my doubts, that's all.

CT: Do you accept any laws on principle?

MD: No, I mean the word *law* is against my principles. At least I think it's unnecessary to call it

law, as though it were inexorable. The concept of causality to me is very dubious. It has a doubtful character. It's a convenient form of making life possible. And all these religious concepts that come out of causality—the idea of God being the first one to do everything is another illusion of causality.

CT: In deciding to stretch the laws of physics and chemistry, were you adopting an ironical point of view?

MD: Yes, with the idea that it would be more of a game, more worth living, to be able to stretch those laws, to make them more elastic.

CT: Because life would be more interesting?

MD: There would be more imagination, more lee-way, more lack of seriousness, more play, more breathing rather than working. Why should man work to live, after all? The poor thing has been put on earth without his permission to be here. He's forced to be here. Suicide is a difficult thing to accomplish. It's *travaux forcés*. That's our lot on earth, we have to work to breathe. I don't see why that's so admirable. I can conceive of a society where the lazies have a place in the sun. My famous thing was to start a home for the lazies—*hospice des paresseux*. If you are lazy, and people accept you as doing nothing, you have a right

to eat and drink and have shelter and so forth. There would be a home in which you would do all this for nothing. The stipulation would be that you cannot work. If you begin to work you would be sacked immediately. There was a book published in 1885, by one of the communist groups in France at that time. The name of the book was *The Right to Be Lazy*. The title says it all, doesn't it? It was a right, without your having to give an account or an exchange. But again, for me, who invented the concept of exchanging? Why should one exchange on even terms? I don't understand how it started, the idea of barter, in the mind of man. Animals do not exchange or take or give according to their worth.

CT: But isn't that in a way a form of protection for the weak or the lazy? If an animal is weak and lazy, he will starve.

MD: I know, but that's it. God knows there's enough food for everybody on earth, without having to work for it. [*laughs*] Who made all those little rules that dictate you won't get food if you don't show signs of activity or production of some kind? No, I mean the give and take, for me, is a very amusing problem. I'm not talking about money now; I'm talking about barter or even the exchange between mother and child. For example, a mother generally gives and never takes from her child except affection. In the family

there is more giving than taking. But when you go beyond the concept of the family, you find the need for equivalences. If you give me a flower, I give you a flower. That is an equivalent. Why? If you want to give, you give. If you want to take, you take. But society won't let you, because society is based on that exchange called money, or barter. But I don't know where it originated, as far as plain living is concerned. And don't ask me who will make the bread or anything, because there is enough vitality in man in general that he cannot stay lazy. There would be very few lazies in my home, because they couldn't stand to be lazy too long. In such a society barter would not exist, and the great people would be the garbage collectors. It would be the highest and noblest form of activity. And since the garbage collectors would do it out of pleasure instead of being paid for it, they would have a medal that would correspond to being the Duke of Windsor today. [*laughs*] I am afraid it's a bit like communism, but it is not. I am seriously and very much from a capitalist country.

CT: Do you feel that science takes itself as seriously as art does?

MD: Science is so evidently a closed circuit, by which you add something to the premises and call it science. But we don't know the half of it. Every fifty years another law is discovered and it goes on

and on. I don't know why we should have such reverence for science. It's a very nice occupation, but nothing more. It has no noblesse to it. It's just a practical form of activity, to make better Coca-Cola and so forth. It's always utilitarian. In other words, it hasn't got the gratuitous attitude that art has, in any case.

CT: But wouldn't you agree that science and technology constitute the most powerful force in our time and have done more to change life than anything else?

MD: Yes, of course. This century of ours is fully scientific and...

CT: And in that sense, can it be said that science, like what you say about art, is a habit-forming drug?

MD: Well, it could...

[*telephone rings*]

Just a second.

[*pause*]

CT: I'm just wondering if you would be inclined to think of science as a habit-forming drug also.

MD: Well, yes, it is, definitely. Especially now, it has

gone so far now that it's really a religion. That's where we come into a vicious circle because we don't...

[*telephone rings*]

There's another one. Just one second.

[*pause*]

CT: Can I ask you whether you were influenced by Alfred Jarry and his science of 'pataphysics?

MD: Oh, yes, indeed. Rabelais and Jarry are my gods, evidently. They were an example to me of what could be unserious and yet express things that were not completely the lowest form of wit. At the same time I had great admiration for Raymond Roussel, who was for me the only man in the last thirty years in literature who started absolutely from a clean slate. Even people like the Surrealists in their writing are continuing Mallarmé, continuing Rimbaud. They were not entirely free from influences. While in Roussel there is a great freedom, no influence that I could detect. He puns a lot. Puns are considered very low, low, low everywhere, in English as well as in French. And he was using a low pun, not even a good pun. The whole century has had a taste for the miserable, in every way. The eighteenth century had been so refined, and so the

reaction went the other way, and it is going on still, very strong.

CT: When did you become a 'pataphysician?

MD: I've been with them, so to speak, since 1942, 1943. I just happen to have a title given to me. They give titles to anyone they want.

CT: What is your title?

MD: I am a satrap. It's a sort of Roman name for soldier, or something like that. I don't know.

CT: I think it is a governor of a province.

MD: Or Greek. I do not know which. Anyway, they used old-fashioned terminology from the Greek civilization or Roman civilization. I mean, they are a bunch of professors, more or less.

CT: But in general the tone is ironic and amusing. It's not totally serious.

MD: No, it's certainly not, but, at the same time, it's very critical. It's highly critical in other ways. They criticize vague and elaborate systems of thinking.

CT: Did your idea of the fourth dimension—that every object that casts a shadow may be itself

the shadow of another object—is that a 'pataphysical idea?

MD: No, no, I don't think so. All this talk about the fourth dimension was around 1900, and probably before that. But it came to the ears of artists around 1910. What I understood of it at that time was that the three dimensions can be only the beginning of a fourth, fifth, and sixth dimension, if you know how to get there. But when I thought about how the fourth dimension is supposed to be time, then I began to think that I'm not at all in accord with this. It's a very convenient way of saying that time is the fourth dimension, so we have the three dimensions of space and one of time. But in one dimension, a line, there is also time. I also don't think in fact Einstein calls it a fourth dimension. He calls it a fourth coordinate. So my contention is that the fourth dimension is not the temporal one. Meaning that you can consider objects having four dimensions. But what sense have we got to feel it? Because with our eyes we only see two dimensions. We have three dimensions with the sense of touch. So, I thought that the only sense we have that could help us get a physical notion of a four-dimensional object would be touch again. Because to understand something in four dimensions, conceptually speaking, would amount to seeing around an object without having to move: to feel around it. For example, I

noticed that when I hold a knife, a small knife, I get a feeling from all sides at once. And this is as close as it can be to a fourth-dimensional feeling. Of course from there I went on to the physical act of love, which is also a feeling all around, either as a woman or as a man. Both have fourth-dimensional feelings. This is why love has been so respected! Anyway, that's an amusing idea that doesn't have to be proved or catalogued.

CT: Your method has been perpetual invention, which can be seen as the scientific method.

MD: It's more the idea that anything I come up with should be given a fourth-dimensional look, so that we can come to see some other side of it that might even be contrary to whatever importance it has or design it makes. I would try to see it with another set of senses, hmm? It's been like that all my life. That's why I say I'm not that interested in art, it's one occupation, it's not all my life, far from it.

CT: Your life has been filled with art. But you don't seem to believe in it all that much.

MD: I don't believe in art. I believe in the artist.

# PHOTO CREDITS

Also by Calvin Tomkins

Intermission

The Bride and the Bachelors

The World of Marcel Duchamp

Eric Hoffer: An American Odyssey

Merchants and Masterpieces: The Story of the
Metropolitan Museum of Art

Living Well Is the Best Revenge

The Scene: Reports on Post-Modern Art

Off the Wall: Robert Rauschenberg and the
Art World of Our Time

Post- to Neo-: The Art World of the 1980s

Alex: The Life of Alexander Liberman
(coauthored with Dodie Kazanjian)

Duchamp: A Biography

Lives of the Artists

**Marcel Duchamp
The Afternoon Interviews**
is available as an enhanced e-book with
additional multimedia content for the
Apple iPad + iPhone, Amazon Kindle,
and other e-readers.

For more information, visit
www.badlandsunlimited.com